Liverpool-to-Liverpool

Liverpool-to-Liverpool

Simon Faithfull

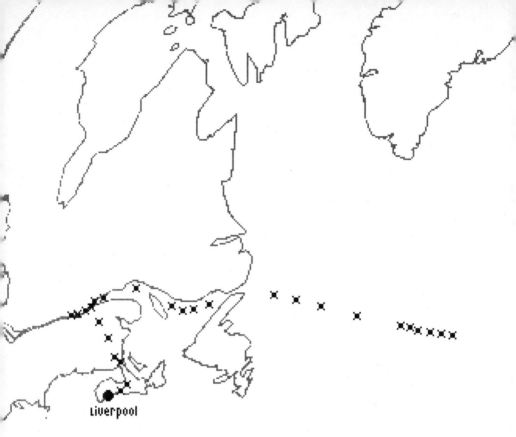

Liverpool

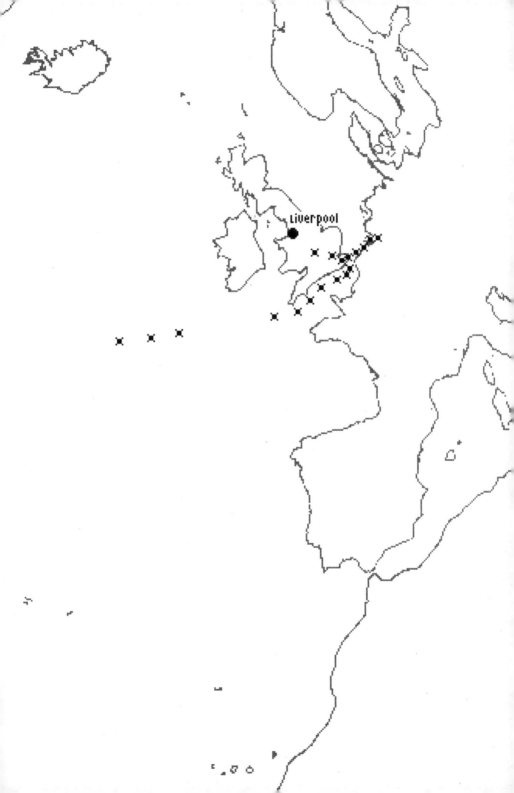

In memory of Joerg Berger, one of whose photographs is featured on the cover.

Contents

From Lime Street to Liverpool: A voyage in pixels, stone and glass

By Joe Moran

In 2002, the Homes and Communities Agency began acquiring the freehold interest in the concourse around Lime Street station, with the aim of turning it into an expanded public space and more welcoming approach to the city. As part of this project they commissioned Simon Faithfull to produce a piece of permanent public art. Faithfull chose to create a work which tells the story of an epic journey from Liverpool, UK, to Liverpool, Nova Scotia, made by the artist in the summer of 2008. Faithfull's images of his journey are engraved into the surfaces of the new concourse, a reminder of Liverpool's maritime past, its historical dependence on the shipbuilding industry and transatlantic trade, and the survival of these global connections today. They offer a visual record of a voyage towards a remote place, one which has much in common with Liverpool apart from its name.

A common thread that runs through all of Faithfull's work is his effort to re-enchant the everyday and find the magical in the mundane: his luminous fake moon lit up 2008's *Big Chill* music festival in Herefordshire, rising and setting like the real thing and fooling many festival-goers; his book, *Lost*, each page telling the story of an object he has lost over the last three decades, was left in random places around Britain for strangers to find and then lose again; *Escape Vehicle #6*, a bogstandard office chair, was sent 18 miles upwards dangling from a weather balloon, the onboard camera showing it nestling between the curvature of the earth and the blackness of space. From an early age, Faithfull says, he was gripped by "a melancholic awareness that I was tethered to this mundane realm" and remembers being jealous of flies because they "could even walk on ceilings".

Faithfull's transatlantic journey is part of the same exploration of our failed attempts to escape "the trivial, the mundane and the self" but also of the beautiful futility of these dreams of escape. His 3000-mile, one-way trip eats up the vastness of the Atlantic and the Canadian landscape but also negotiates the bathos of a Virgin Pendolino train and the two-lane roads of Nova Scotia. Faithfull's initial plan was to sail directly from Liverpool to Montreal, but his container

ship, the *Joni Ritscher*, was diverted to Belgium, so on 9th September 2008, he set off from Lime Street for the south coast and then got the early morning ferry to Antwerp to catch the container ship to Montreal. From Montreal he took the train to Halifax, then hopped on a bus and, three weeks after leaving Lime Street, arrived in Liverpool – a small town of just over 3000 people. Naturally, it was named after its British counterpart and also lies on the banks of a river Mersey.

That most of Faithfull's miles are covered by container ship is not without its ironies. Like many ports, Liverpool, UK has suffered serious downsizing on the back of the rise to global dominance of the ISO (International Standards Organisation) shipping container: that uniform, stackable steel box invented in the 1950s by the American trucking entrepreneur Malcolm McLean, so that goods would not have to be handled when transferring between ships and lorries. These omnipresent cuboids, which Faithfull calls the "quantum units of 21st century life", are usually seen by ordinary mortals when they are stacked high and stationary near railway lines and motorways. But their parallel, invisible lives are spent in Lego-like stacks in these gargantuan container ships – at 175m long, the *Joni Ritscher* is a relative midget – carrying the flotsam and jetsam of modern consumerism, from Nintendo Wiis to Nike trainers. Their snail-slow, Homeric voyages are normally noticed only by customs officials and pirates.

Faithfull made about six drawings a day throughout his journey, documenting the detail of daily life on land and sea, from Liverpool to Liverpool, with his Palm Pilot. These sketches are necessarily simple, because the screen on his hand-held device is tiny and the act of drawing with the stylus is fairly tricky: you can scroll sideways to make the drawing bigger, but then this means you can't see the whole image at once. Yet the improvised, on-the-hoof, quietly observational quality of these drawings somehow fits the quotidian nature of their subject matter, and it is striking how the simplicity and economy of the pixilated line still manages to convey the vivid particulars of the journey, and picks out the contrasts between English Liverpudlians crouched under umbrellas and Canadian Liverpudlians with moustachioed lips and pickup trucks.

One of the main advantages of drawing digitally was that Faithfull could easily transfer the images into other forms and send them out electronically – an idea he developed on a previous, two-month residency with the British Antarctic Survey, when he emailed his Palm Pilot drawings of icebergs and penguins across the world. In Liverpool, Nova Scotia, Faithfull used a local copyshop to make 181 postcards of his drawings. Having taken the Liverpool (UK) phonebook with him, he then posted the cards to random addresses in it, all saying "Wish you were here". (Despite being in the Liverpool phonebook, I wasn't lucky enough to receive one.)

In a creative collision between the newly virtual and the conventionally concrete, these 181 digital drawings have now been sandblasted into the stone pavings and etched into the glass arches at the entrance to Lime Street station. Each drawing is given latitude-longitude coordinates inscribed beneath it in the corner of the glass or stone – the kind of navigational northing and easting now familiar to most of us from satnav systems – so that the viewer has a precise location, which in theory they can go away and explore further should they so wish (although please note that the herring gull perched on a lamppost at N.53°24.30 W.2°59.77 may no longer be there).

Harassed train passengers, hurrying through the new concourse to catch trains or taxis, might well miss Faithfull's relatively unobtrusive artwork. Indeed, its modesty offers a refreshing counterpoint to the spectacularly visual nature of most urban regeneration projects. Such projects tend to favour the grand gesture: an eye-catching new building or a multi-million pound facelift, aimed at instantly changing perceptions about a place and attracting tourists and potential investors. Faithfull's project instead insists on the importance of the local and vernacular, and the persistence of history and memory in even the most modernised environments. This book includes all 181 digital drawings, and Faithfull's often wry, imagist commentary on the landscapes he was passing through and the humans he encountered as he drew them. Both the words and images attest to the survival of the texture and detail of individual everyday lives even in our restlessly mobile, globalised world.

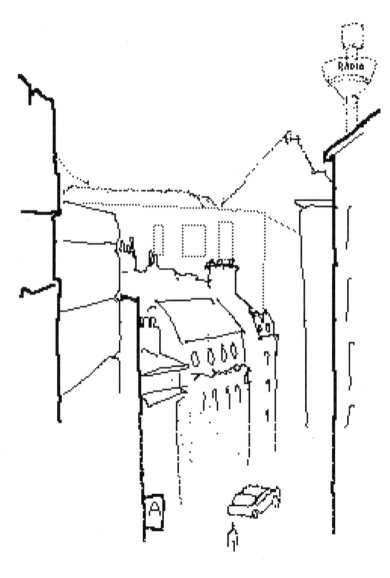

1.Liverpool n.53°24'34 W.2°59'47

2. Liverpool n.53°24'19 w.2°59'25

3. liverpool n.53°24'36 w.2°59'42

4. Liverpool n.53°24'36 W.2°59'43

5. Liverpool n.53°24'36 W.2°59'42

6. Liverpool n.53°24'33 w.2°59'23

7. Liverpool n.53°24'33 W.2°59'23

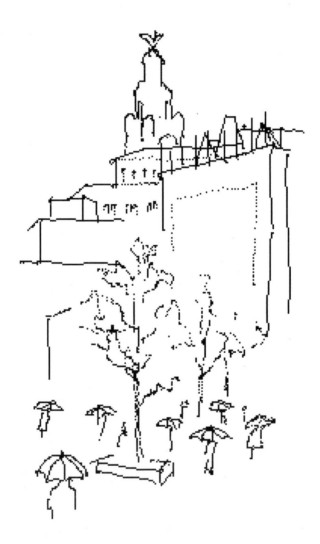

8. Liverpool n.53°24'32 W.2°58'99

9. Liverpool n.53°24'29 W.2°59'36

CASA BELLE

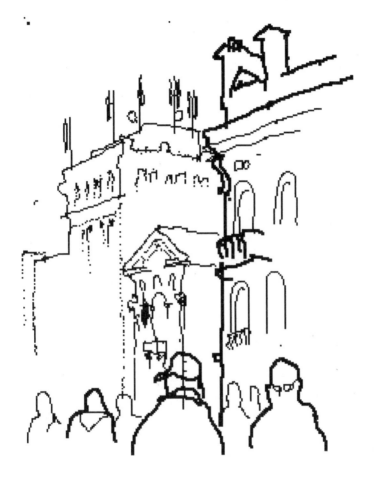

11. Liverpool n.53°24'32 w.2°59'38

13. Liverpool n.53°24'08 W.2°59'70

14. Liverpool n.53°24'08 W.2°59'70

15. Liverpool n.53°24'08 W.2°59'70

16. Liverpool n.52°24'06 w.2°59'70

17.Liverpool n.53°24'33 w.2°59'42

18. Liverpool N.53°24'32 W.2°59'38

19. Liverpool n.53°24'47 W.2°59'07

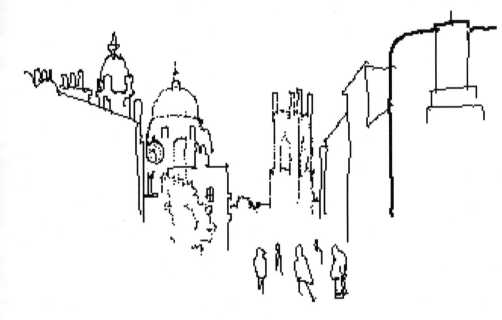

20. Liverpool n.53°24'46 W.2°58'01

21. Liverpool n.53°24'27 W.2°58'50

22. Liverpool N.53°24'27 W.2°58'49

23. Liverpool n.53°24'28 W.2°58'68

24. Liverpool n.53°24'32 W.2°59'39

25. liverpool n.53°24'48 w.2°59'99

26. Liverpool n.53°24'26 W.2°59'63

27. Liverpoool n.53°24'38 w.2°59'57

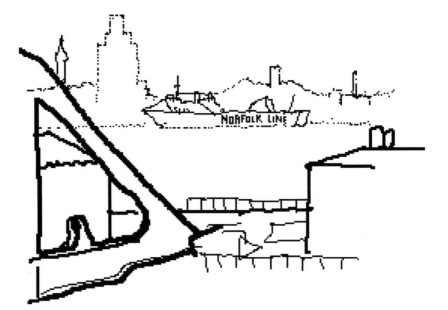

NORFOLK LINE

28. Liverpool n.53°24'37 W.2°59'91

29. Liverpool n.53°24'30 W.2°59.77

30. Liverpool n.53°24'66 w.3°00'10

31. Liverpool n.53°24'41 W.2°59'49

32. Liverpool n.53°24'40 W.2°59'49

33. Liverpool n.53°24'41 W.2°59'49

34. liverpool n.53°24'41 w.2°59'87

35. liverpool n.53°24'41 w.2°59'49

36. liverpool n.53°24'28 w.2°59'32

37. Liverpool N.53°24'03 W.2°58'05

38. Liverpool n.53°24'03 W.2°58'05

39.liverpool n.52°24'28 w.2°59'32

40.liverpool n.53°24'28 W.2°59'32

41. Liverpool n.53°24'28 W.2°59'32

42.liverpool n.53°24'05 w.2°58'14

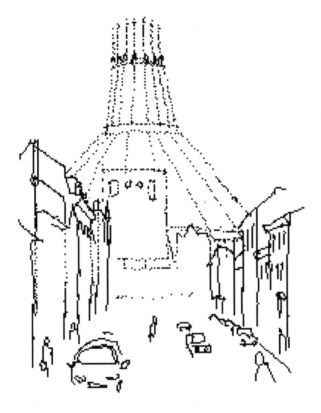

43. Liverpool n.53°24'09 w.2°58'23

44.liverpool n.53°24'28 w.2°59'32

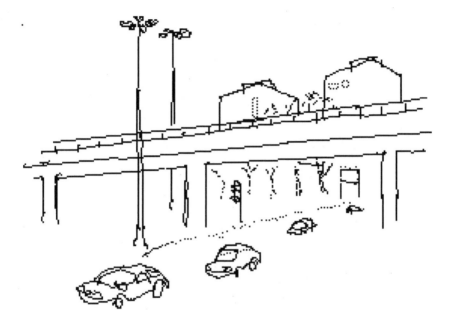

45. Liverpool n.53°24'56 w.2°58'94

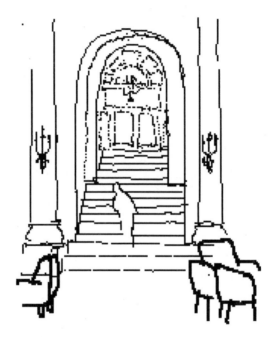

46. Liverpool n.53°24'36 W.2°58'67

47. Liverpool n.53°24'36 W.2°59'49

48. Liverpool N.53°24'33 W.2°59'42

49. Liverpool n.53°24'47 W.2°58'78

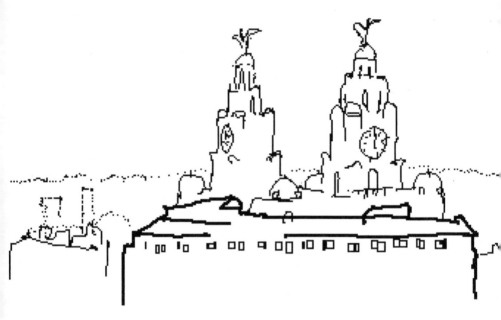

50. Liverpool n.53°24'25 W.2°58'43

51.liverpool n.53°24'42 w.2°58'73

Farshaudemolition

52. Liverpool n.53°24'48 w.2°58'79

54. liverpool n.53°24'45 w.2°58'71

55. Liverpool n.53°24'46 W.2°58'74

56. Liverpool n.53°24'42 W.2°58'61

57. nr. stafford n.?° w.?°

58. EUSTON N.51°31'67 W.0°07'98

59. Euston n.51°37'42 W.0°08'02

61. nr. Ashford n.?° E.?°

62. Ramsgate N.51°19'36 E.1°24'30

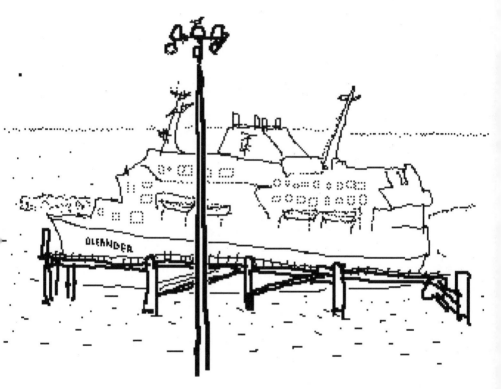

63. Ramsgate n.51°19'43 E.1°24'51

64. Ramsgate n.51°19'32 E.1°24'59

65. Ramsgate N.51°19'31 E.1°25'11

66. Ramsgate n.51°19'43 E.1°24'51

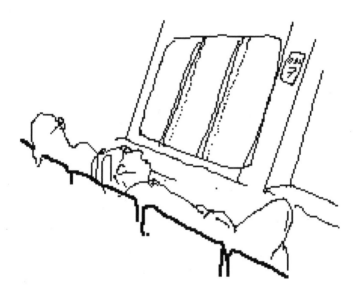

67. north sea n.51°18'41 e.1°43'08

68. north sea n.51°15'56 E.2°26'28

69. Oostende n.51°13'54 E.2°54'28

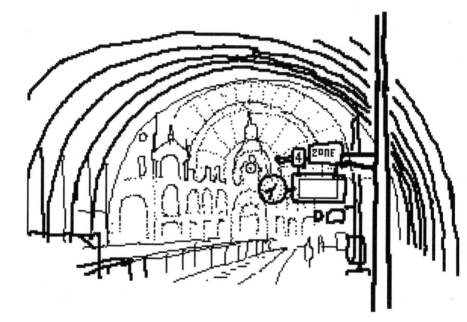

70. Antwerp n.51°13'02 E.4°25'16

71. Antwerp n.51°12'36 E.4°24'59

72. Antwerp n.51°15'54 E.4°24'47

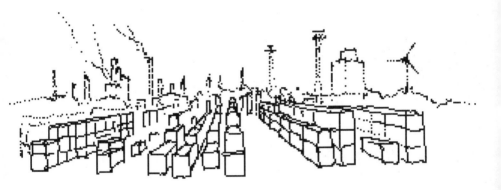

73. Antwerp n.51°20'98 E.4°16'07

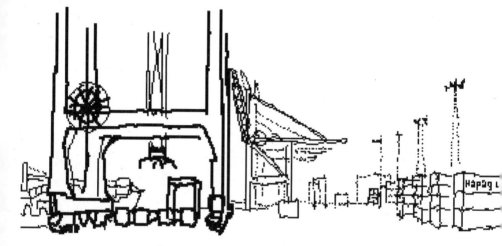

74. Antwerp n.51°20'98 E.4°16'07

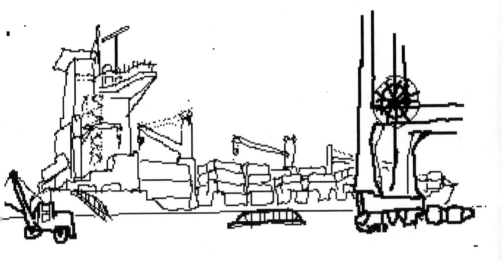

75. Antwerp n.51°20'98 E.4°16'07

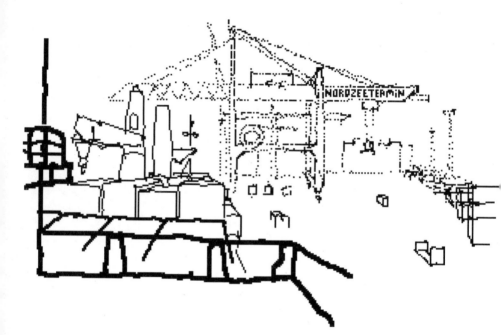

76. Antwerp n.51°20'98 E.4°16'07

77. Antwerp n.51°20'57" w.4°16'07"

78. Antwerp n.51°20'98'' w.4°16'08''

79. Antwerp N.51°20'26.36" E.4°15'49.94"

80. English Channel n.50°47'10.42" E.0°58'06"

81. English Channel N.50°32'45.55" E.0°13'38.40"

82. English Channel n.50°25'47.42" w.0°47'25.85"

83.channel n.50°14'11" w.2°20'17"

84. English Channel n.49°55'16" W.3°55'99"

```
.......''.. .·´‾‾‾‾‾‾‾‾‾‾‾‾‾‾‾‾‾‾‾‾‾‾‾‾‾‾‾‾‾‾‾‾‾‾‾‾‾‾‾‾‾‾‾‾‾‾‾‾‾‾‾‾‾‾‾‾‾‾‾‾‾‾‾‾‾‾‾‾‾‾‾‾‾‾‾.....
...........´..............  .. ..... .... ....  . .  ..... ..... ...... ....  .... `......::............
```

85. Lands End n.49°48'61" W:5°14'13"

86. Atlantic n.49°44'53" w.7°14'8"

87. Atlantic n.49°44'53" W.7°14'8"

88. atlantic n.49°44'53" w.7°14'8"

89. Atlantic n.50°5'87" W.15°10'09"

90. Atlantic N.50°12'06" W.17°23'42"

91. Atlantic n.50°18'44" W.19°52'3"

92. Atlantic n.50°44'48" W.29°53'58"

93. Atlantic n.51°05'14" W.37°43'48"

94. atlantic n.51°05'14" w.37°43'48"

95. Atlantic n.51°05'59" W.38°00'37"

96. Atlantic n.51°9'23" w.39°11'55"

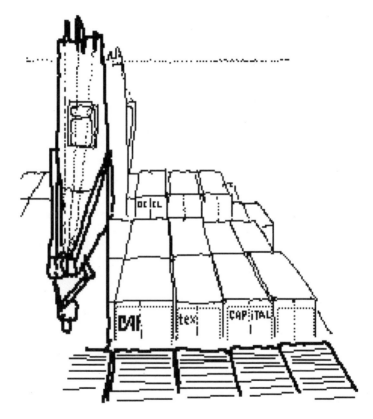

97. Atlantic n.51°12'13" W.40°23'49"

99. Atlantic n.51°14'33" w.41°20'45"

100. Atlantic n.51°15'71" W.41°49'12"

101. Atlantic n.51°25'23" w.45°19'26"

102. Atlantic n.51°33'42" W.48°33'31"

103. Atlantic N.51°39'29" W.50°57'17"

[Joerg Berger]

104. Atlantic n.51°43'90" w.52°40'73"

105. Gulf of St. Lawrence N.50°26'16" W.58°41'54"

106. Gulf St. Lawrence n.50°00'92" w.60°04'59"

107. Gulf of St. Lawrence n.49°59'27" W.60°38'59"

108. Gulf of St. Lawrence N.49°57'43" W.61°52'59"

109. St. Lawrence n.48°15'29" W.69°27'06"

110. St.Lawrence n.48°14'4" W.69°28'16"

111. St.Lawrence n.48°12'11" W.69°30'9"

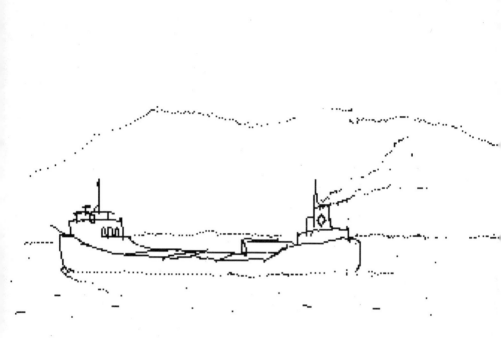

112. St. Lawrence n.48°10'48" w.69°31'39"

113. st.lawrence n.48°9'8" w.69°33'15"

114. St. Lawrence n.48°7'8" W.69°36'26"

115. St. Lawrence N.48°5'9" W.69°37'33"

116. St.Lawrence n.47°23'56" W.70°27'61"

117. quebec n.46°51'28" w.71°00'41"

118. quebec n.46°50'40" w.71°4'45"

119. quebec п.46°50'18" ш.71°9'38"

120. montreal n.45°35'49" w.73°30'18"

121. montreal n.45°35'23" w.73°30'23"

122. montreal n.45°35'23" w.73°30'23"

"123. montreal n.45°35'23" w.73°30'23"

124. montreal n.45°35'23" w.73°30'23"

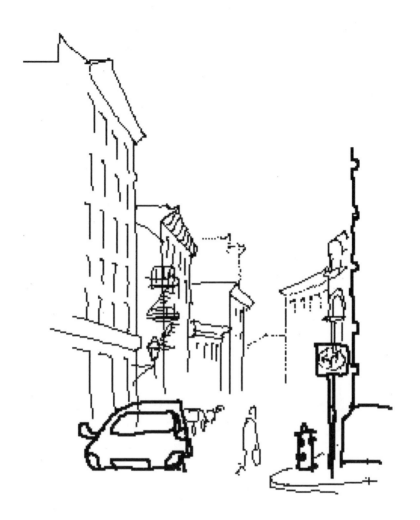

125. montreal n.45°30'01" w.73°33'43"

126. montreal n.45°30'12" w.73°33'44"

127. montreal n.45°30'12" w.73°33'17"

128. montreal n.45°30'38" w.73°33'38"

129. montreal n.45°30'14" w.73°33'42"

130. montreal n.45°30'07" w.73°33'42"

131. montreal n.45°30'07" w.73°33'42"

132. montreal n.45°30'07" w.73°33'42"

133. montreal n.45°30'17" w.73°33'45"

134. montreal n.45°30'09" w.73°33'49"

135. montreal n.45°30'44" w.73°34'10"

136. montreal n.45°33'37" w.73°36'45"

137. montreal n.45°32'49" w.73°37'35"

138. montreal n.45°32'61" w.73°37'72"

139. montreal n.45°32'36" w.73°37'43"

140. montreal n.45°29'59" w.73°34'0"

141. montreal n.45°29'59" w.73°34'0"

142. montreal n.45°29'10" w.73°32'45"

143. montreal n.45°30'5" w.73°30'0"

144. new Brunswick n.46°4'13" W.64°50'54"

145. new Brunswick n.46°06'67" W.64°46'04"

146. new brunswick n.46°07'68" w.64°42'88"

147. new Brunswick n.45°53'12" w.64°18'57"

148. nova scotia n.45°3'42" w.63°25'13"

149. nova scotia n. 44° 47' 14" w. 63° 38' 26"

150. Halifax n.44°38'24" W.63°34'09"

151. Halifax N.44°38'24" W.63°34'09"

152. Halifax n.44°38'21" W.63°34'4"

153. Halifax N.44°38'53" W.63°34'20"

154. Halifax n.44°38'25" W.63°34'14"

155. Halifax n.44°38'53" W.63°34'19"

156. Halifax n.44°39'03" W.63°34'44"

157. Halifax n.44°39'02" W.63°34'32"

158. Halifax n.44°38'89" W.63°34'22"

159. Halifax n.44°38'89" W.63°34'22"

160. Halifax n.44°39'05" W.63°34'33"

161. Halifax N.44°38'36" W.63°34'20"

162. Halifax N.44°38'37" W.63°34'11"

163. nova scotia n.44°07'21" w.64°38'57"

164. nova scotia n.44°5'11" w.64°40'42"

165. nova scotia n.44°4'1" w.64°41'47"

166. Liverpool N.44°02'28" W.64°42'44"

167. Liverpool n. 44° 02' 36" W. 64° 42' 85"

168. Liverpool n.44°02'27" W.64°42'43"

169. liverpool n.44°02'27" W.64°42'43"

171. Liverpool n.44°02'74" W.64°43'18"

172. Liverpool n.44°07'36" W.64°41'06"

173. Liverpool n.44°02'46" W.64°42'67"

174. liverpool n.44°07'16" W.64°40'86"

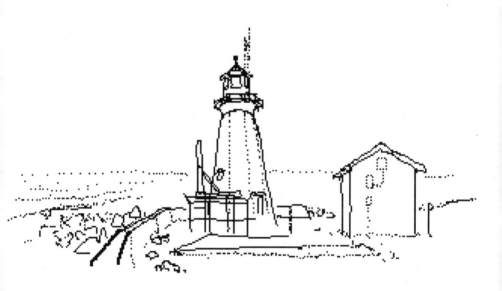

175. Liverpool N.43°59'24" W.64°39'42"

176. liverpool n.44°02'30" W.64°42'90"

177. Liverpool n.44°02'30" w.64°42'90"

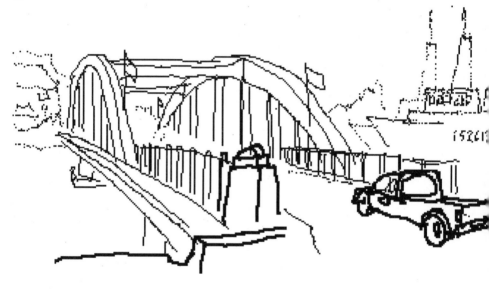

178. Liverpool n.44°02'41" W.64°42'97"

179. Liverpool n.44°02'19" W.64°41'33"

180. Liverpool n.44°02'64" W.64°39'64"

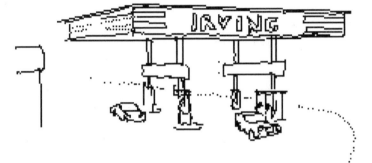

181. Liverpool n.44°02'69" W.64°43'29"

The rain smells of the sea. Gulls sit on the CCTV cameras and watch for an opportunity. On the waterfront, between the huge old buildings, the roads are silent except for the wind. The money made from journeys at sea settled into these grand blocks a long time ago. Now they wait like ships that will never move again.

The rain shakes the coffee chain's windows – the rubber soles of my shoes leak and so I am sheltering in the dry. A pigeon has slipped through the doorway to escape the downpour. There is a thud as its grey body hits the pane of glass. A ball of kinetic feathers, it flaps above the tables and bounces off the window again. It falls to the ground in confusion. Turning its head from side to side, it waits to understand and watches the Scousers drinking coffee.

My container ship is not coming to Liverpool. I have been here for a week wait-
ing to board the *Joni Ritscher* but at the last minute the ship has been diverted
to Antwerp because of repairs in the Liverpool docks. So I leave Liverpool not
by sea but by train through the network of tunnels that were cut into the lime-
stone hills to create the world's first railway.

Half of the continent fled from Europe through these tunnels travelling by ship
towards the promises of America. But I'm travelling in the opposite direction –
Virgin train to one of the channel ports, cross-channel-ferry and then train
again to Antwerp.

The *Oleander* slips out of the harbour into a still sea. The first rays of sunlight have just hit the top of the white cliffs. Above the chalk cliffs the people and dogs of Ramsgate are still deep asleep.

The *Oleander* is staffed exclusively by dark haired Slovenians catering to an empty ship. They are courteous and enthusiastic but understand little or no English – they smile and say *please* as they point to the English breakfast.

The interior of the *Oleander* is dotted with bodies. Within minutes of leaving, the few lorry drivers are hibernating – curled in favourite niches throughout the empty bars and restaurants. From the windows at the front I watch the prow of the boat sailing into the sparkling water of early morning.

The taxi drives me through an Antwerp Sunday. Twisting through the Dutch looking streets and markets of the old town, through the Jewish orthodox quarters, the banal European suburbs and out onto the Euro-motorways. We glide across the flat polders and fields until finally, against a grey horizon, the silhouettes of the container-dock cranes appear. Each framework has four girder-legs, a long gantry body and a pylon-neck stretched high in the air. As we get nearer they grow larger and larger.

I get in the back of a minibus and it drives me through the rows and columns of containers. A mathematical construction built from stacks of cuboids – all exactly identical except for their colour and logos. Driving through the legs of the idle cranes the minibus pulls up alongside the *Joni Ritscher*. 175 metres long, the ship is almost fully loaded with its stacks of containers. One crane is still lifting the last few boxes through the air. I walk up the gangway and the minibus drives away.

The *Joni Ritscher* leaves berth 941. On the dock the cranes and the mountains of containers are still. In the open water ahead there is a channel marked out with slowly pulsing lights. The ship glides between glowing beacons that top the swaying buoys. Green lights pass by on the left, red lights wink by on the right. Shadows of ships pass near by. A towering cliff-face of steel passes on our port side and for a while blocks out the entire sky. The other container ships make the *Joni Ritscher* seem like a river barge. The sky gets darker and the waterway gets wider. On the distant banks we pass power stations and chemical works – castles of white industrial lights and a wobbling flame of burning gas.

The last lights are behind us and in the blackness we move with the swell. The engines throb through the ship.

There is a small bird that flies around the ship – dusty coloured like a sparrow or warbler. An accidental stowaway – something fragile from the land. We are now in the ocean but it is still flitting between the oily cables and railings. Somehow it seems to know that it must stay with the ship. It's a calm day and at the moment, when it flies from perch to perch, it is still faster than the air. What will happen when the weather changes?

I imagine the bird blown by the gales – flying further and further over the surf looking for the metal island in vain.

Passing Land's End there is a faint grey line on the horizon and for a moment my mobile phone finds a network – 2 flickering bars of connection blowing in the wind. The last contact or news from dry land for 9 days to come – I send a text before the bars flicker away.

The container ship is ploughing straight towards the setting sun. The steel plates beneath my feet are pulsing with the drone of the diesel engines – pushing the metal through the waves.

The ocean is endless in every direction. A liquid planet spinning through space. As we travel across the water we live by a 23-hour clock. We lose an hour a day as we chase the sun – thumping through the waves in the opposite direction to the earth's spin. But we are losing. The water is too thick and the planet is too fast – the sun races towards the horizon and we fall behind into the following shadows of twilight. The cold sun is almost lost behind the curve of the sea. A final lunge of the ship's prow down into the water and the last sliver of gold evaporates behind the waves. The darkening sky is enormous. The wind blows uninterrupted across hundreds of thousands of miles. The *Joni Ritscher* lurches and moans in the swell but above the rolling containers the first stars are perfectly still.

Today, the same procedure. The sun rose behind us – emerging where our trail across the water meets the horizon. It chased after us through the sky and left us behind again as it slipped beneath the waves – pulling the night across the ocean behind it.

The *Joni Ritscher* is comparatively small – built to carry 1,856 containers, each 20 ft x 9 ft x 9 ft, stacked five deep beneath deck and three high above. Quantum units of 21st century life slowly making their way around the planet. T-shirts, computers, hairdryers, the contents of somebody's house. Some have fans and cooling systems to keep their chickens and lambs frozen to a standard temperature – all are sealed with a special tab to prevent theft. The captain tells us that in the South Seas there used to be a modern form of piracy. The container ships were so huge that the skeleton crews needed a moped to get from one end to the other. In the night, the pirates pulled alongside in tiny boats, scaled the steel sides and then slowly moved from container to container searching for loot before slipping away again into the night. These days off the coast of Africa desperation drives new pirates to simply take the whole ship for ransom. The captain tells us how he stations men with baseball bats at the hole where the anchor-chain comes through the side of the ship.

A walk after dinner is either clockwise or anti-clockwise. 1,856 containers, 6 passengers and 17 crew packed in a metal can. A tight little kingdom ruled by the grumpy captain from above and by the fat chief-engineer from below. There is a dizzy paradox of scale. We are all stuck on a 175 m chunk of steel – a finite lump pushing through the water. But beyond the rails we are embedded in a boundless army of waves. Claustrophobia and agoraphobia wash over each other.

The ocean is an alien. A landscape becomes familiar over time as we get to know different folds in a range of hills. But a landscape of water can never be grasped. There is no difference as far as the eye can see. In *Solaris*, Stanisław Lem describes a future where mankind has discovered an ocean planet that is in fact one huge, undulating mind. When you are in the middle of it, the ocean feels like this – a giant brain that is hard at work dreaming unfathomable thoughts that go on for ever, in every direction, for always. An organism that is totally indifferent to your presence. I love it. It's a fantastic thinking space – in fact you can't avoid thinking – there is something hypnotizing about the waves and the air that pulls out thoughts from your mind like a seagull working at a clam.

Outside the porthole the wind shrieks and blasts the tower that contains my Cabin. The 30 ft engine throbs through the steel plate from 8 storeys below and the sea throws us back and forth. Two floors above me on the bridge, Genesis (the Filipino 2nd mate) is on watch but in my bunk I'm swimming in and out of sleep. Sleeping while moving is an exotic pleasure. Warm and dry and carried across the ocean into the wild night.

At night Genesis is alone on the bridge. It seems that the hundreds of tons of steel are almost totally satellite controlled. Genesis fills the hours playing solitaire on his laptop whilst in theory he's driving the ship. He only gets up every hour or so to answer a bleep or a ping – like somebody waiting for a microwaved meal.

The waves are now breaking over the stacks of containers. The prow of the ship collides with each wall of water and a storm of white surf races along the 175 metres of boat towards the bridge – obscuring the cranes and cables as it comes. As it hits each wave, the ship lurches with a deep thud in its bowels and then moments later the spray hits the line of windows along the bridge – 10 floors above the ocean. Intermittently, nine windscreen wipers spring into choreographed action and then fall back to sleep. The prow breaks the next wave and so we continue onwards.

In the night whilst I'm asleep the remote control boat slips into the mouth of the St Lawrence and leaves the ocean behind. We reach the lee of Anticosti Island – the wind drops and the swell calms. After hours of steaming up the Sound, the sea only very gradually gives way to river. The shores are distant lines of green but they gradually grow closer until they are near enough to see the odd house or village.

Heads start to appear in the water – blinking at the ship before slipping back under the surface. There are flashes of fins as creatures roll through the water – seen in the distance or suddenly appearing under the prow of the ship. A fellow passenger deciphers these glimpses as seals, dolphins and Minke whales. A little further on, she explains that the pack of 20 or so slow-moving, white-shadows are a pod of passing Beluga whales. I can't see beneath the surface of the waves but it must be like Piccadilly Circus down there.

We stop at a prearranged point near a small town on the banks – a fast boat arcs out from the jetty and pulls alongside. The pilot climbs the rope ladder and then pulls up his overnight bag after him. He quickly climbs the flights of stairs up to the bridge and assumes control of the ship. Little is said. The radio is tuned to a French language station pumping out bland American rock. Numbers and co-ordinates are exchanged. As the sun sets, the lights of Quebec City come into view around a bend in the river. We sail under giant bridges, past docks and city towers and the illuminated tourist attraction of a massive waterfall. The ship stops and another boat pulls alongside. Pilots are exchanged and we continue up the St Lawrence with the new pilot guiding us through the night.

For the past 9 days my mobile phone has been demoted to the role of an alarm clock that lies next to my bed. Since Land's End it has been searching in vain for a network and now at six in the morning its ring frightens me awake – someone in England calling me unaware of my location and time zone. As a result I get to the bridge just in time to see the sun rising on the left and the towers of Montreal appearing ahead.

The pavement is moving with phantom waves. It's strange to be walking in a straight line again. Strange to have choices and even stranger to be walking through an American movie dubbed into a foreign language. The brownstone buildings, the corner stores, the huge trucks – everything could be the US (perhaps the east village in New York) and yet everyone is speaking French. The city proposes a kind of 'what if' history game. In a parallel universe, where things had worked out differently, president Bush might also be speaking French. Actually, other things are also subtly wrong – the bodies are American but the gestures and the way people hold themselves is French. The dress sense is more stylish, the café culture is slower, the food is excellent, the women are beautiful. I like Montreal.

I shut the door of my Orient Express cabin and we pull out of Gare Centrale. The train belongs to a 1930s idea of travel. The guard for my carriage knocks on my door and asks me whether I would like the first or second sitting for dinner, breakfast and lunch. We creep through the tatty backyards of Montreal – rattling along badly aligned rails and lurching over the points.

With the city behind us the top speed still seems to be about 50 miles an hour – two days trundling through the forests of New Brunswick. The back of the train is something from a Buster Keaton movie – a club car with aluminium armchairs and wrap-around windows. At the very back is a door at the centre of the curving metal walls. The window in the door looks directly back along the rails and perfectly frames the receding tracks as they disappear into the forest. At the other end of the car there is a half-spiral staircase flanked by a row of 5 clocks set to the various Canadian time zones. Up the stairs is the viewing deck – 1950s airline seats and a ceiling of glass that arches above the passengers' heads. The viewing deck is about 2 foot higher than the rest of the train so that you can look forward across the roofs of the carriages towards the distant engine. Mesmerized by the view, I sit for hours watching the train twisting through the yellowing, reddening leaves of the forests. Eventually I'm the last passenger left on the deck and in the failing light I watch the landscape slide endlessly, emptily past.

Halifax seems like an echo of Britain – at night I have fish and chips and a pint of bitter in an oak beamed pub. The next day I kill time by wandering along the waterfront – watching the gulls steal food from the tables whilst I wait for my ride.

The driver opens the window and spits into the wind. As we take the corners, the air brakes whine like a child and the bus trundles on along the two-track highway of Nova Scotia. Birch trees, pine trees, rocks, water and sky. The seat behind the driver is stacked with parcels and packages that he drops off at the *IRVING* gas stations spaced every half hour or so along the route. Occasionally there is a person as well as a package – a Japanese tourist, an old couple in nylon, a lad in combat and baseball cap. The road loops between the ocean and the forest – coming back to meet the water at little rocky bays and river mouths. The names on the passing traffic signs seem like scattered refractions of Europe: Dartmouth, Yarmouth, Bedford, le Havre, East Berlin, West Berlin, Lunenburg – a lonely coast sprinkled with names by other homesick wanderers.

The daylight fades and soon the bus rides in total darkness. The only lights are the dials on the driver's dashboard and our headlights sweeping through the white trunks of the trees ahead. Finally the driver tells me that I have arrived in Liverpool – another *IRVING* gas station and a few retail outlets at a junction in the road. The driver opens the side of the coach and I heave out my bag. I ask him for Lane's Hotel and he points into the darkness – "down the hill, just before the bridge". I wheel my bag through the night until the pavement begins and I can see the lights of a small town.

Nobody understands me. As I open my mouth I see a rising panic in their eyes. Sometimes they make a wild guess at what I mean but often they just look at me. Liverpool consists of a few streets of clapboard houses. In the centre they are quaint and historic but as you walk out of town the houses get tattier. Bits of broken cars stacked at the foot of the veranda, dogs barking on chains – weirded out by the sight of a walker. At night Liverpool has a hotel, a pizza parlor and bowling alley – every second car is a pickup, every other top lip has a moustache.

The next day I persuade someone to rent me a bike and I cycle out of town to the headland and lighthouse. On a promontory someone has left a 1970s plastic leather sofa. I sit and look out across the ocean – facing the way I came. The seagulls and shags perch on the rocks and observe me as I watch the rollers coming in across the Atlantic. As they curl over and around the air, the belly of each wave glimmers with a deep internal blue. For a moment there is a glimpse through a wall of water to the space beneath the waves.

Liverpool-to-Liverpool Simon Faithfull

Liverpool-to-Liverpool is the public art component of the
Lime Street Gateway project, delivered by a partnership of
Liverpool City Council, Homes and Communities Agency,
Liverpool Vision, Northwest Regional Development Agency,
European Regional Development Fund, Network Rail,
Merseytravel and The Railway Heritage Trust.

The commissioning process for *Liverpool-to-Liverpool*
was supported by Liverpool Biennial.

British Library Cataloguing-in-Publication Data
A British Library CIP record is available

ISBN 9781846314889

Simon Faithfull would like to thank:
Cliff Steinberg, Dennis Brant, Sue Jones, Antony Pickthall,
Mark Diaper and Rebecca Rowles.

Designed by Simon Faithfull and Mark Diaper (Eggers + Diaper)
Cover photograph Joerg Berger
Printed by Medialis Berlin

Published and distributed by:
Liverpool University Press
4 Cambridge Street
Liverpool, L69 7ZU